PUGS in SPACE

PUGS in SPACE

JACK RUSSELL

amber
BOOKS

Published by
Amber Books Ltd
United House
North Road
London N7 9DP
United Kingdom
www.amberbooks.co.uk
Instagram: amberbooksltd
Facebook: www.facebook.com/amberbooks
Twitter: @amberbooks

ISBN: 978-1-78274-512-9

Project Editor: Sarah Uttridge
Designer: Rick Fawcett
Picture Research: Terry Forshaw

Printed in China

Contents

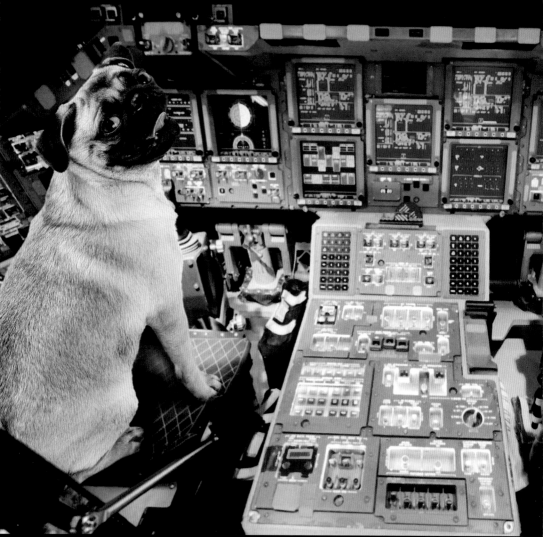

Who Chewed the Instructions?

"Don't panic. I can drive an automatic. It's easy, especially as I grew up driving a stick shift."

Pug Fact: It has been claimed that the pug became the official dog of the House of Orange in the Netherlands in the 16th century after William the Silent's pug, Pompey, saved his life by alerting him that assassins were approaching.

Space Fact: Between 1981 and 2011, the five NASA Space Shuttles flew a total of 135 missions.

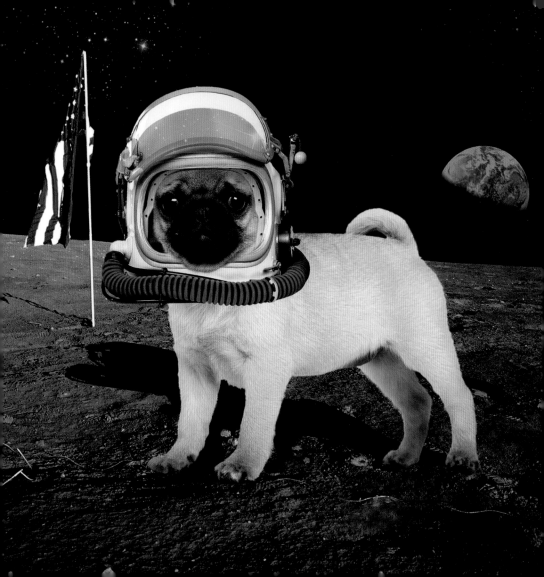

First Pug on the Moon

"You think this looks unreal? Oh, yeah? And I suppose you think they faked the Moon landings, too."

Pug Fact: Pugs were imported into the United States in the 19th century. In 1885, the American Kennel Club first recognized pugs as a distinct breed.

Space Fact: The first spacecraft to reach the surface of the Moon was the Soviet Union's unmanned Luna 2 mission, which landed on September 13, 1959.

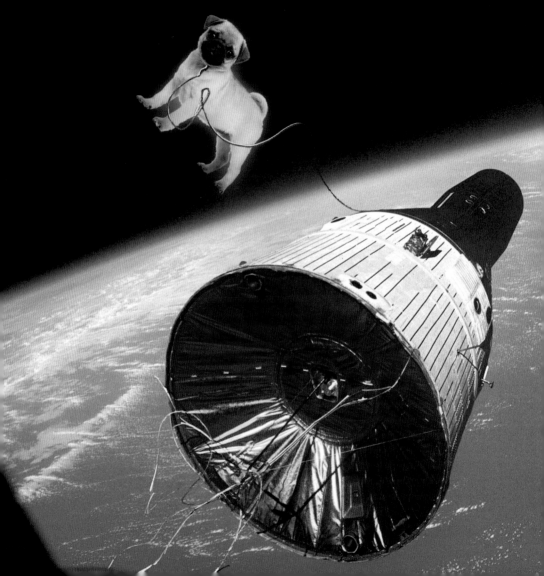

Going for a Spacewalk

"It's funny how things look so different from up here. I thought humans were much bigger."

Pug Fact: Princess Provost Hedwig Sophie Augusta of Russia would often travel with up to 16 pugs at once, and always had one accompany her to church.

Space Fact: Russian cosmonaut Alexey Leonov made the first spacewalk in 1965.

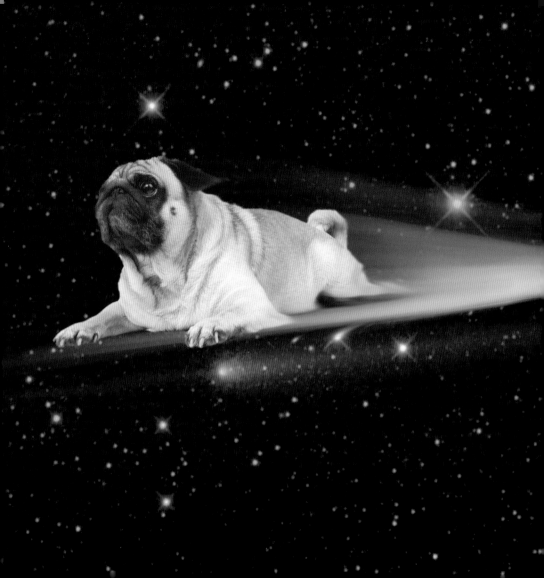

Hot on the Tail

"I envy that comet its long tail."

Pug Fact: Pugs catch colds easily. They are quickly stressed by hot or cold weather because they cannot regulate their body temperature very well.

Space Fact: When an orbiting comet passes close to the Sun, it is warmed by the Sun's heat. The comet releases gases, which create an atmosphere around the comet and, in some cases, a tail.

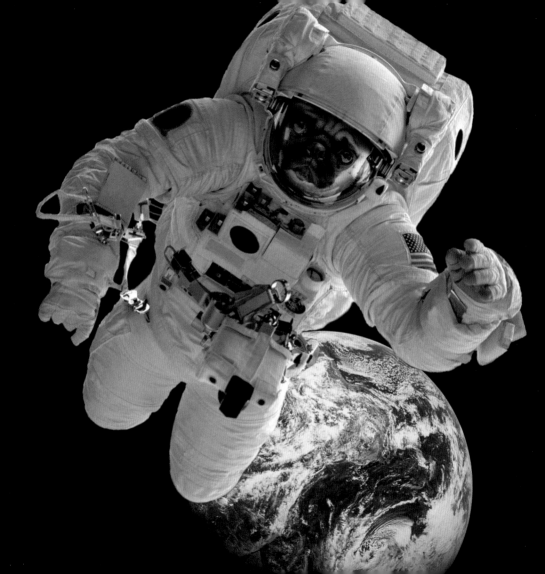

This is Pug to Ground Control

"Planet Earth looks—wait, I don't know. I'm color-blind."

Pug Fact: Mice, spiders, cockroaches, monkeys, snails, jellyfish, guinea pigs, and dogs have all been launched into space, but no pugs.

Space Fact: David Bowie's single "Space Oddity" was released five days before the launch of the Apollo 11 mission, which led to the first manned moon landing.

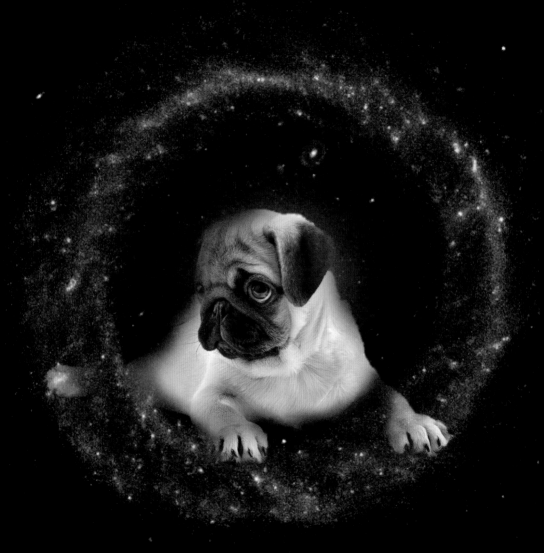

Off the Leash

"If ever there was a hoop in space waiting to be jumped through, I've found it."

Pug Fact: Alternative names for pugs are Dutch bulldog, Dutch mastiff, mini mastiff, and Carlin.

Space Fact: Hoag's Object is a ring galaxy that is 600 million light years away.

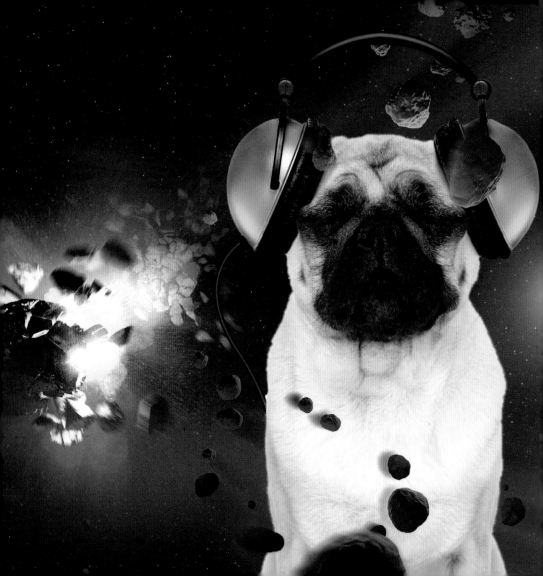

Pug Dogged by Asteroid

"If asteroids are leftovers, please don't order a doggy bag and warm them up on my account."

Pug Fact: In the 16th century, wealthy Dutch women kept pugs for their body heat. Holding pugs helped the women stay warm when their large homes were cold.

Space Fact: Asteroids are mainly composed of rock and minerals. The majority of known asteroids circle between the orbits of Mars and Jupiter, in an area called the asteroid belt.

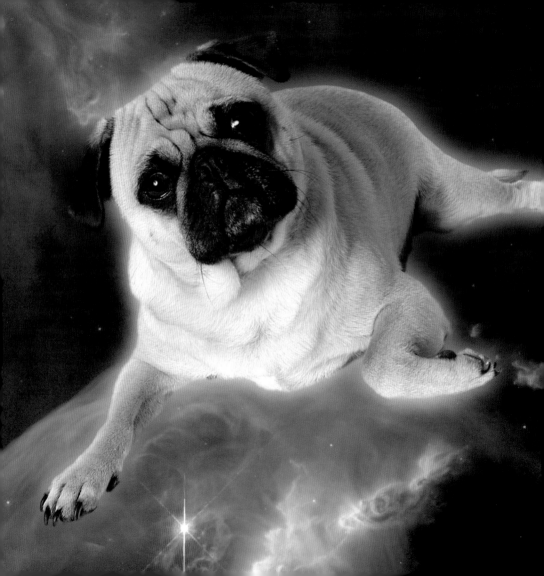

Puggish Personality

"I like Bones the most of all the *Star Trek* characters. Why? Well, it's not his bubbly ways, if you get my drift."

Pug Fact: In the 17th century, pugs were used by armies as guard dogs and as tracking animals.

Space Fact: The "bubble" in the Bubble Nebula is caused by a stellar wind from a star.

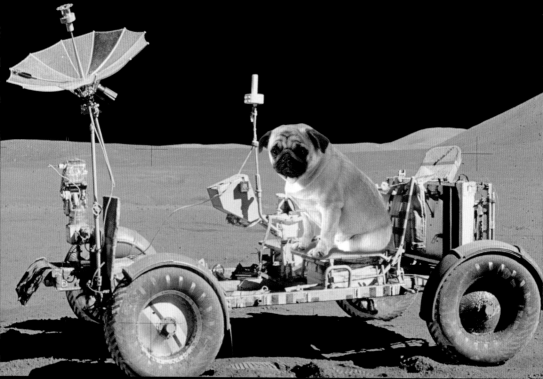

Lunar Rover

"At least there's noone up here checking to see if I've got a driver's license."

Pug Fact: In 2015, a pug named Atom became an internet star when his owners started posting pictures of him driving cars, tractors, speedboats, and even a motorbike!

Space Fact: The Lunar Roving Vehicle has remained on the Moon since the astronauts of the Apollo program left it there in 1972.

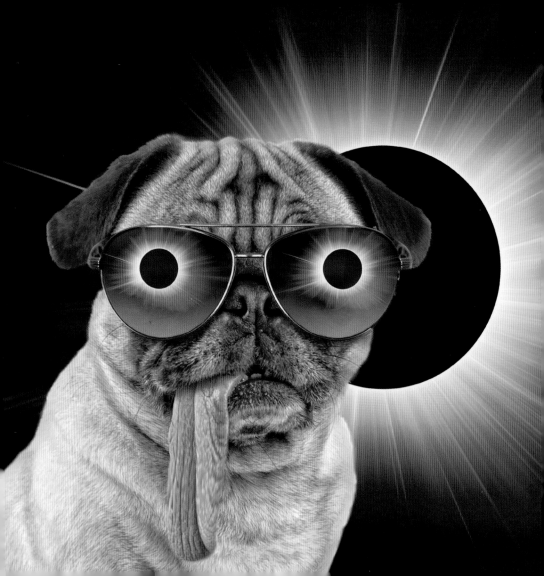

Future Looks Bright for Pugs

"When it comes to fashion, I'm light years ahead."

Pug Fact: When traveling in the carriages of Italian aristocrats in the 19th century, pugs were often dressed in colorful pantaloons.

Space Fact: During a total solar eclipse, Earth is still mostly illuminated, with just a small dark patch showing the Moon's shadow.

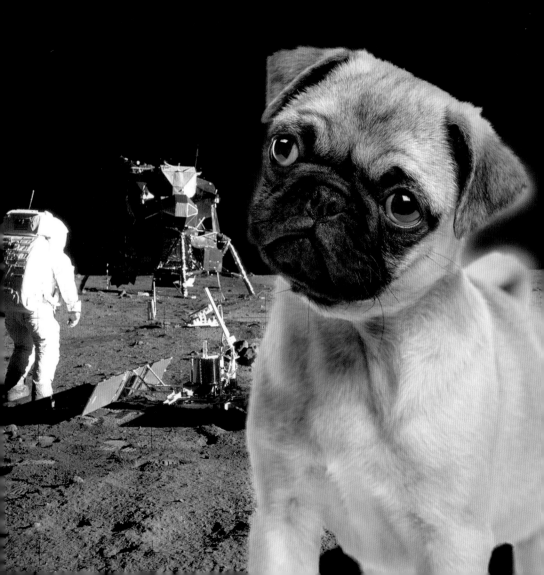

Moon Puggie

"Great. 'Someone' packed a camping stove. What'll it be? Hot dogs? Now, don't tell me, 'someone' forgot the matches."

Pug Fact: In 1740, a secret Masonic society called the Order of the Pug (*Mopsorden*) was formed in Germany. Group members chose pugs as their symbol, because pugs are known for their loyalty and trustworthiness.

Space Fact: Manned and unmanned lunar missions have left more than 400,000 pounds (181,440 kg) of material on the Moon.

Hounds of Love

"Listen, there are only two of us on this planet, so we're just going to have to get along, okay?"

Pug Fact: Napoleon Bonaparte's wife, Josephine, had a pug called Fortune. She used the pug to send messages to her husband. Unfortunately, fortune didn't favor Fortune, and, one day, it had a fatal encounter with the chef's bulldog.

Space Fact: The gravity on the planet Mars is only 37 percent as strong as Earth's. This means you could leap nearly three times higher on Mars than on Earth.

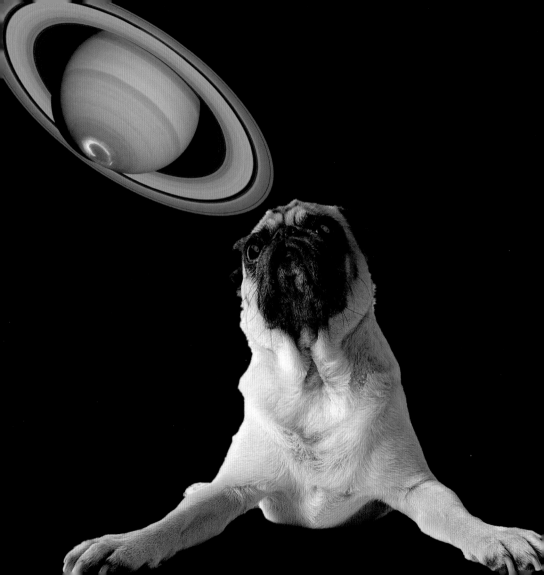

Planet Pug

"Now, that's a planet I'd cross the Solar System to fetch. Those rings look like a Frisbee to me."

Pug Fact: *Pug* may be a corruption of *Puck*. Puck was the name of a mischievous elf from English folklore and a character in Shakespeare's *A Midsummer Night's Dream*.

Space Fact: Saturn has nine main rings. They are mostly made of water ice, with a small amount of rocky materials.

Puggle Hubble

"You would agree, wouldn't you, that this piece of advanced space technology actually looks like a trash can."

Pug Fact: Pugs and beagles have been crossbred since at least the 1980s, creating "puggles."

Space Fact: Launched in 1990, Hubble is the only telescope designed to be serviced by astronauts. On five Space Shuttle missions, repairs or upgrades have been made to the Hubble.

Just Press Paws

"To be honest, I'm more of a Mac user myself, but I'll have a go at anything."

Pug Fact: Two of the 20th century's most famous pug lovers were Prince Edward, Duke of Windsor and former king of the United Kingdom, and his wife, Wallis Simpson.

Space Fact: On October 4, 1957, the Soviet Union launched Sputnik 1, becoming the first country to send an object into Earth's orbit.

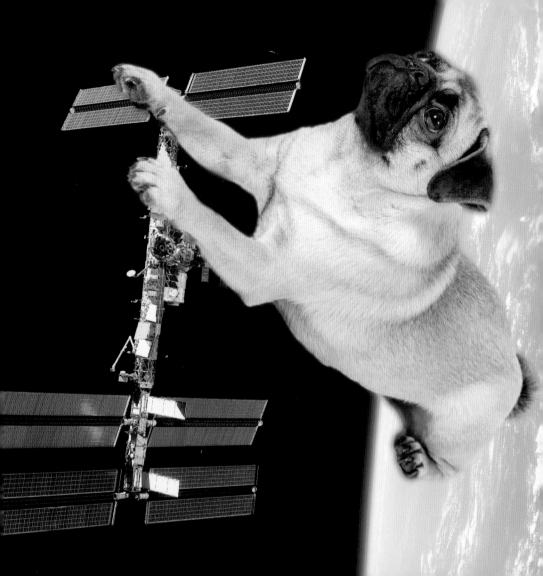

Doggone It

"I never knew that they based the shape of the International Space Station on a bone."

Pug Fact: It is believed that the pug was introduced to Europe from Asia by the Dutch East India Company.

Space Fact: Launched into orbit in 1998, the International Space Station is a joint project from five space agencies: CSA (Canada), ESA (Europe), JAXA (Japan), NASA (United States), and Roscosmos (Russia).

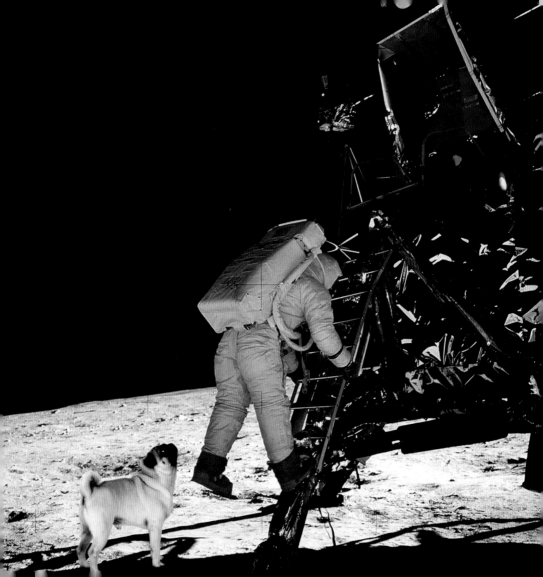

Howling at the Man on the Moon

"If Neil Armstrong was the first man on the Moon, who set up the camera to film him? Well, now you know."

Pug Fact: Queen Victoria bred pugs, encouraging their popularity in 19th-century Great Britain.

Space Fact: Neil Armstrong became the first human to step foot on the Moon on July 21, 1969.

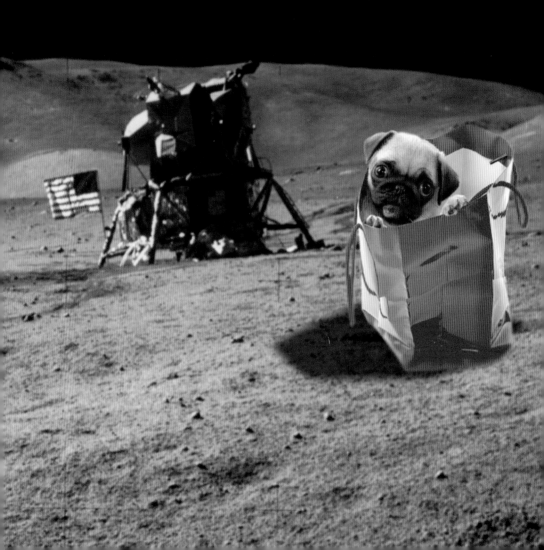

Enough Space for a Pug

"She always brags about how she can take me anywhere. Well, this time she's really done it."

Pug Fact: At 4 inches (10 cm) tall and weighing just 1 pound, 4 ounces (0.6 kg), a pug called Pip from western central England was declared the world's smallest pug in 2015.

Space Fact: The average distance between the Moon and Earth is 238,900 miles (384,500 km).

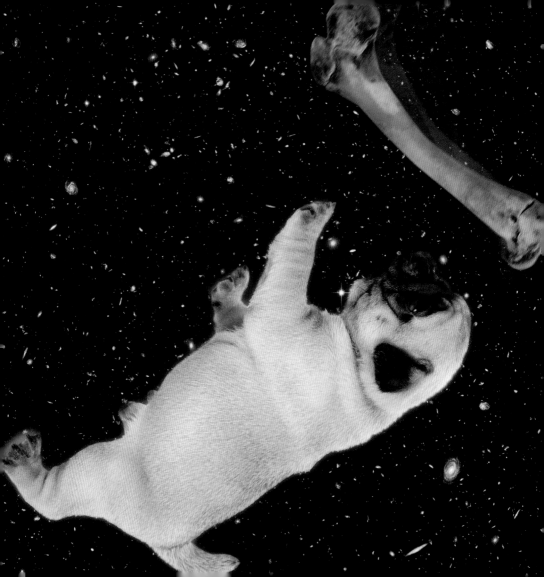

The Unbearable Density of Pugs

"Do you think that bone went soft in space? I really hope not."

Pug Fact: During the Tang Dynasty in China (AD 618–907), pugs were sent as state gifts to Japan and Korea.

Space Fact: After several days in microgravity, the calcium stored in astronauts' bones is released into the bloodstream. This leaves bones weak and less able to support the body's weight and movement upon return to Earth.

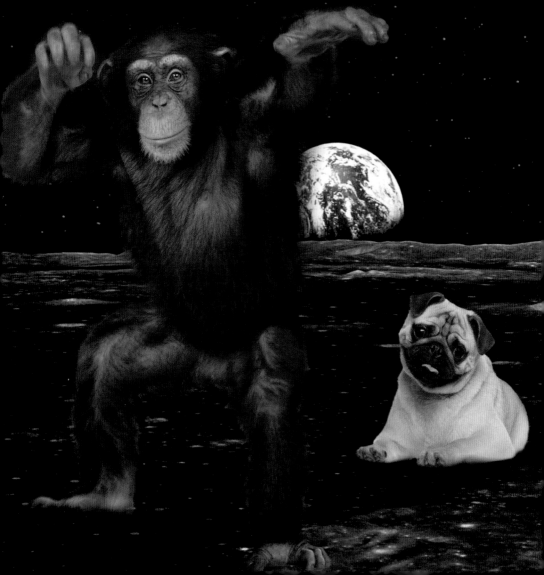

Pug Goes Ape

"What on Earth—or should I say, the Moon—is this?"

Pug Fact: In 17th-century England, "pug" was a nickname used for a dog or for a monkey.

Space Fact: The first monkey in space was Albert II, a rhesus macaque, launched on an American V2 rocket in 1949. He survived space, but sadly died on his return when his parachute failed.

45

Bow-Wow-Meow

"I'm stuck here, in the Sea of Tranquility—with a cat!"

Pug Fact: Pugs are not very good swimmers because of their short and stout bodies.

Space Fact: On October 18, 1963, France launched the first cat into space. Félicette survived her 15-minute flight and parachute descent.

Who Let the Pug Out?

"Now, this amusement park ride really is out of this world."

Pug Fact: Rather than having guard dogs to protect important humans, Chinese emperors had human guards to protect royal pugs.

Space Fact: The mechanical arm used on the Space Shuttles was called Canadarm, because it was designed in Canada.

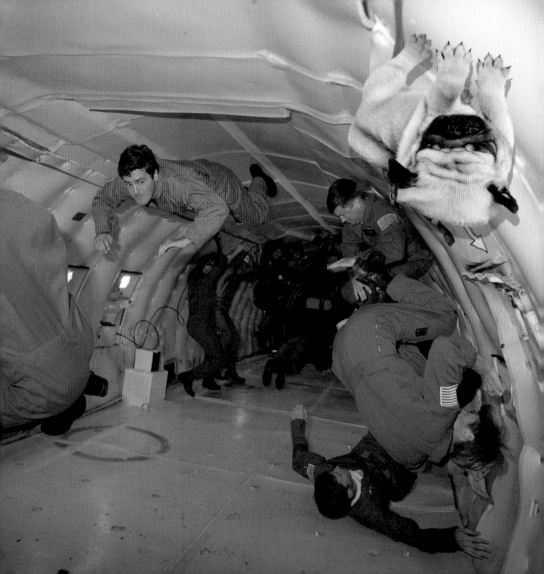

Pet Insurance Skyrockets

"It's a good thing I don't get carsick."

Pug Fact: In ancient China, pugs were considered hunting dogs, not toy dogs.

Space Fact: Reduced gravity aircraft are used to train astronauts for the experience of weightlessness when in orbit. To achieve this, the aircraft go into controlled free fall at certain points during the flight.

51

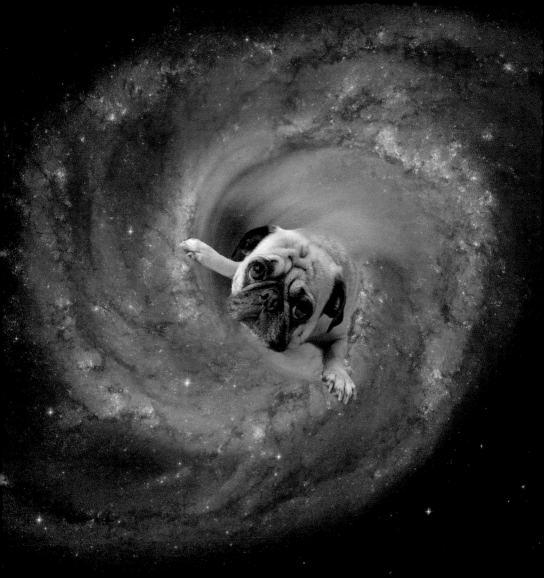

I Spy with My Spiral Eye

"I usually like being the center of attention."

Pug Fact: On average, pugs live for 12 years, but a few have lived for as long as 20.

Space Fact: Spiral galaxies are particularly bright because they contain many young, bright blue stars.

53

One Tasty Comet

"To boldy chew where no dog has chewed before."

Pug Fact: Some of the most sought-after pugs are porcelain. Porcelain pugs produced by the Meissen Factory are worth tens of thousands of dollars.

Space Fact: Commonly known as dirty snowballs, comet nuclei are made up of rock, dust, and water ice, along with frozen gases such as carbon dioxide and methane.

Nobody Can Hear Me Bark

"Those dishes can pick up a lot of signals, but I ask you, can they hear a dog whistle?"

Pug Fact: Queen Victoria banned the cropping of pugs' ears in Great Britain.

Space Fact: On Earth, sound travels by vibrating the molecules in air. There is no air in deep space, so there is no sound.

The Right Stuff

"I do wonder how some of these mutts made it through basic training."

Pug Fact: While the collective noun for crows is a "murder," and for lions it's a "pride," a group of pugs is a "grumble."

Space Fact: By November 2016, a total of 552 people from 36 countries had reached 62 miles (100 km) or more in altitude, exceeding the 50-mile (80-km) threshold necessary to be called astronauts.

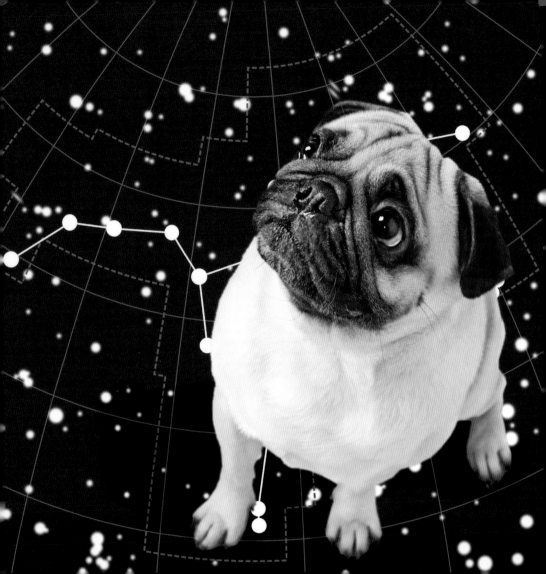

Hunting the Great Bear

"You know, at this distance, the Great Bear really doesn't look threatening at all."

Pug Fact: In 1981, a three-year-old pug won Best in Show at the 105th Westminster Kennel Club Dog Show in New York. This is the only time a pug has won the title.

Space Fact: The constellations are, very slowly, changing shape. Two of the stars in the Great Bear constellation are moving in the opposite direction from the others. In 10,000 years' time, the shape of the Great Bear will be different.

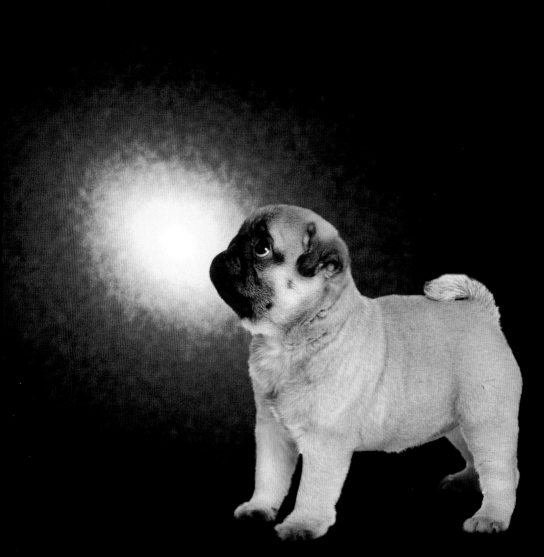

Pug Begs to Differ

"I'm told that is a whole galaxy, but I don't know; it kind of looks like someone spilled something."

Pug Fact: When pugs tilt their head and you think that it's so cute, they're just trying to hear you better.

Space Fact: The word *galaxy* comes from the Greek word for "milky," in reference to the Milky Way.

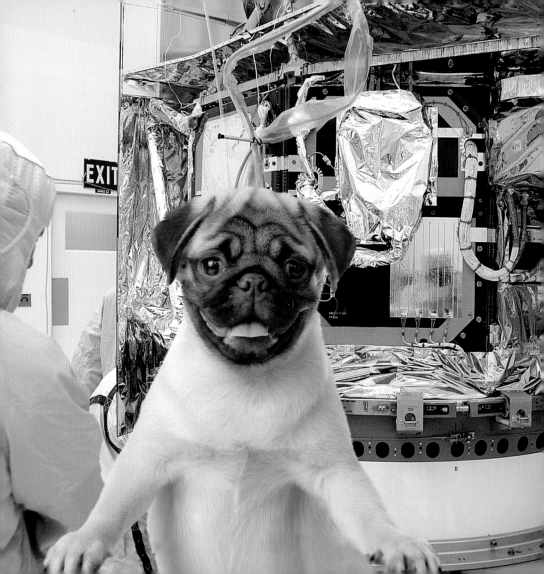

Test Pilot Pug

"See, I told you it wasn't me who stole all the foil."

Pug Fact: A pug called Double D Cinoblu's Masterpiece was judged Best in Show out of 2,000 entries at the 2004 World Dog Show in Rio de Janeiro.

Space Fact: The Spitzer is an infrared space telescope launched in 2003. Having exhausted its liquid helium supplies in 2009, most of its instruments are no longer operational, but two cameras are still sending images back to Earth.

Dog Tired

"Do you know the great thing about space travel? There is plenty of napping time."

Pug Fact: Pugs sleep for about 14 hours a day.

Space Fact: In 2005, it was reported that one of the Spitzer's earliest images may have captured the light of the first-ever stars in the Universe.

Pug Pens Doggerel

"Starlight, stars bright, first billion stars I see tonight ... Wait! Is that an owl?"

Pug Fact: In Italy, pugs are called "Carlino," after the 18th-century actor Carlo Bertinazzi, who was best known for playing the character Harlequin wearing a a puglike mask.

Space Fact: Galaxies range in size: dwarf galaxies have just a few billion stars, while giant galaxies have one hundred trillion stars, each orbiting its galaxy's center.

Sick as a Dog

"Weightlessness I can stand—if I could stand at all—but trying to walk on a nebula makes me queasy."

Pug Fact: Pugs' ears come in two types: rose or button.

Space Fact: A nebula is an interstellar cloud of dust, hydrogen, helium, and other ionized gases.

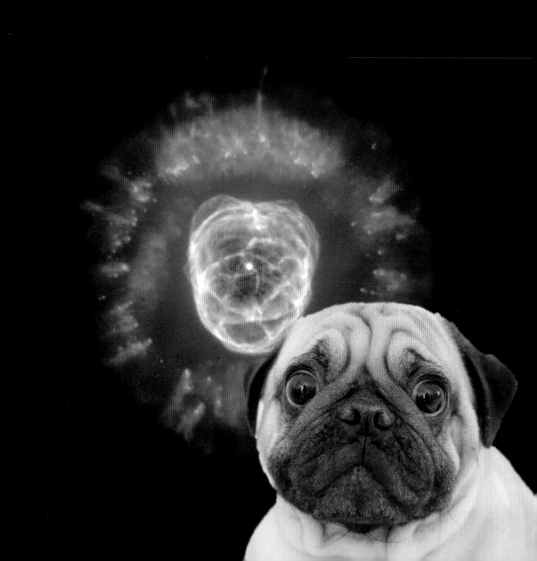

Puggie Love

"If I stare at this long enough, will I hypnotize myself?"

Pug Fact: There are now dating events for pug lovers. Even when their dates don't work out, the human participants still get to meet some pugs.

Space Fact: The heart-shaped Eskimo Nebula is an emission nebula, consisting of an expanding, glowing shell of ionized gas ejected from old red giant stars.

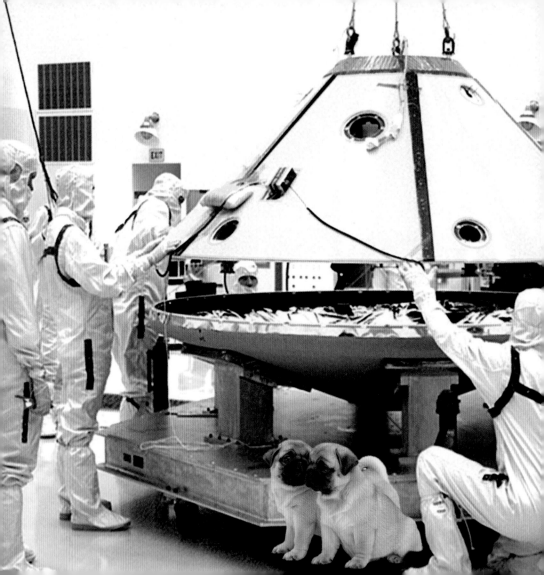

Space-Age Dog Wash

"The truth is, they can't find the on–off switch."

Pug Fact: Pugs come in four colors: apricot, fawn, black, and silver.

Space Fact: Mars, the second smallest planet in the Solar System, is often referred to as the Red Planet, because the iron oxide present on its surface gives it a reddish color.

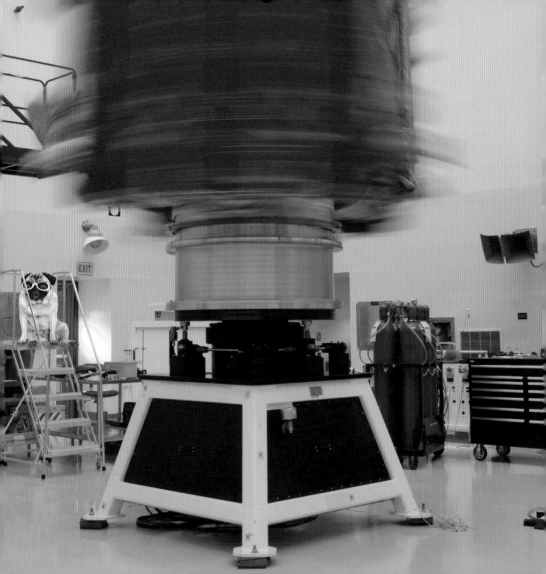

Pug-tri-fuge

"Flying in that would certainly straighten out my wrinkles."

Pug Fact: Pugs are brachycephalic, meaning that their heads are wide but short, giving them that squashed-face look.

Space Fact: The MAVEN probe was given spin balance testing before being launched to Mars in 2013.

Year of the Pug

"Is this my lucky star? I should check my Chinese horoscope."

Pug Fact: Lady Anna Brassey is credited with making black pugs fashionable in Great Britain after she brought some back from China in 1886.

Space Fact: Fomalhaut is one of the brightest stars in the sky. The name comes from the Arabic for "Mouth of the Fish."

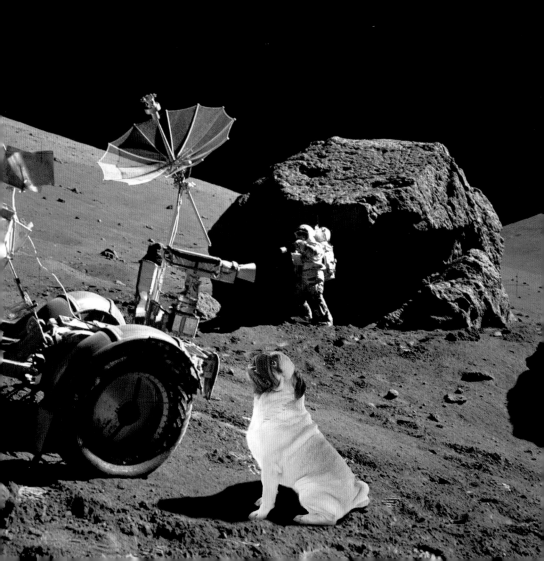

Relief Mission

"It's been a very long flight, and I'm desperate to, well, you know. There aren't any trees, so this tire will have to do."

Pug Fact: It is possible that the word *pug* comes from the Latin word *pugno*, which means "fist," because a pug's face resembles a fist.

Space Fact: By 2013, three countries had sent space exploration vehicles—rovers—to the Moon: China, Russia, and the United States.

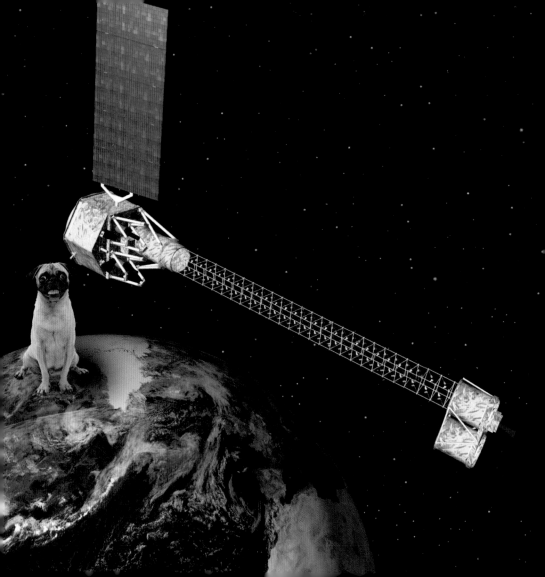

Pug Shot

"Finally, they've found it: the galaxy's biggest selfie stick!"

Pug Fact: The English artist William Hogarth included his pug, Trump, in his 1745 self-portrait *The Painter and his Pug.*

Space Fact: NuSTAR is an X-ray telescope that takes pictures of black holes.

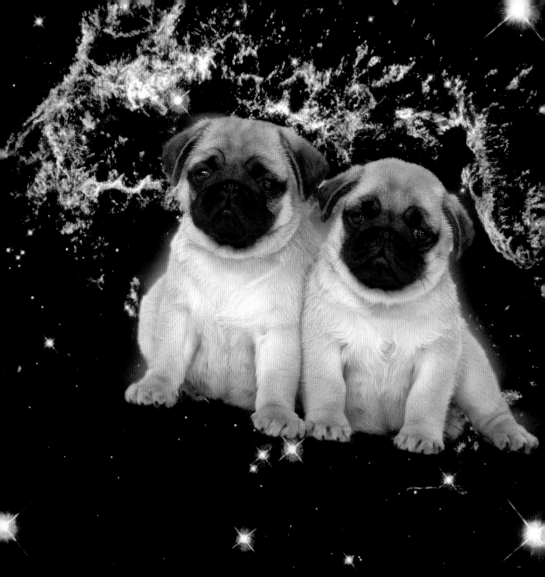

Light Years Beyond Cute

"How sweet—there are holiday lights in space."

Pug Fact: Pugs are the largest of the toy dogs, which are the smallest breeds of dogs.

Space Fact: Found in the constellation Cassiopeia, the supernova Cassiopeia A exploded 300 years ago.

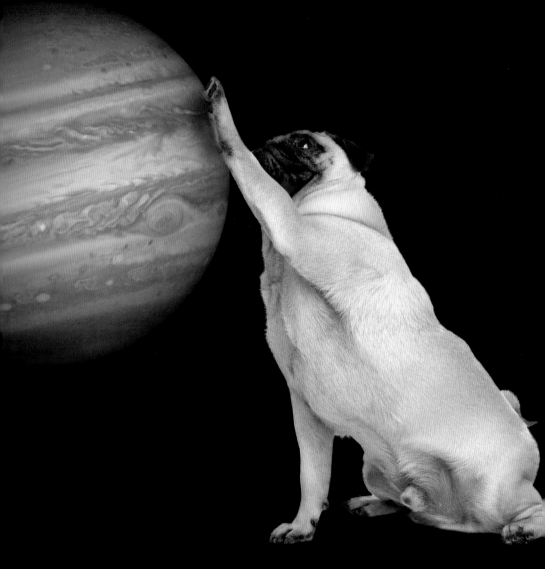

Smartest Pug in the Galaxy

"If I spin this fast enough, will I make time accelerate? I'm not sure, but my afternoon will certainly fly by."

Pug Fact: The pug has ancestral ties to the Pekingese and perhaps the Shih Tzu.

Space Fact: Planets are rounded by their own gravity.

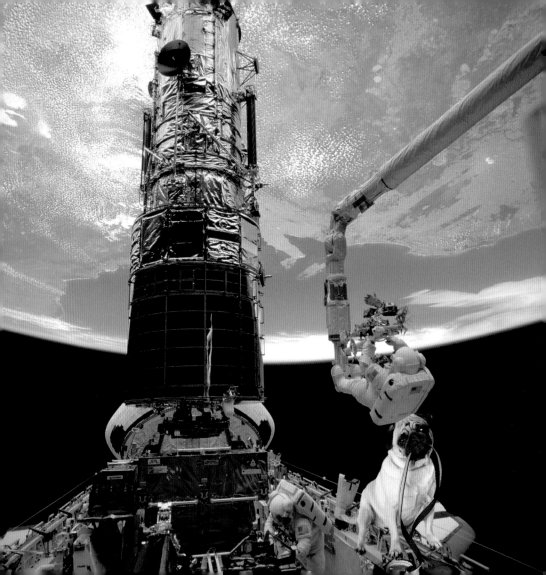

Pug Lost in Space

"In these parts, if you want me to come back, you really have to keep me on a leash."

Pug Fact: The English actor and playwright David Garrick mocked London women who kept pugs close by in his 1740 satire *Lethe*.

Space Fact: The Sun is the nearest star to Earth, but it is still 93 million miles (150 million km) away.

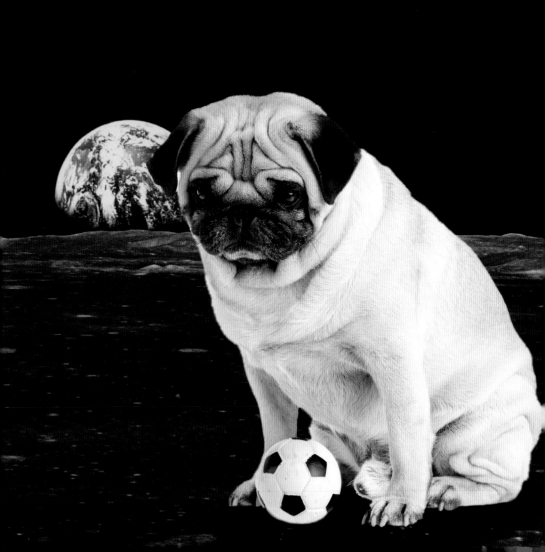

Pug Shoots for the Moon

"I just have to kick the ball, and it will go so far, it will be stratospheric."

Pug Fact: A pug can run from 3 to 5 miles (5 to 8 km) per hour.

Space Fact: During the Apollo 14 mission to the Moon in 1971, astronaut Alan Shepard hit two golf balls on the lunar surface. He drove the second, as he put it, "miles and miles and miles."

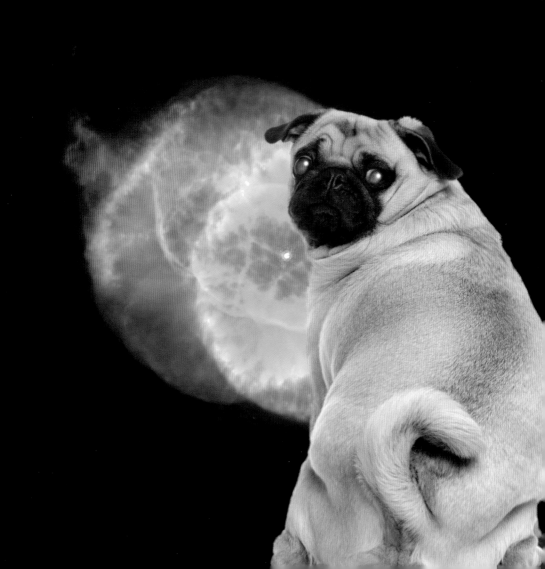

Dog Whisperer to the Stars

"There's no way there's a cat's eye up here. Surely that's a lava lamp."

Pug Fact: *Zhu*, meaning "Pearl," is a popular name for a pug in China.

Space Fact: Compared to the other interstellar phenomena, planetary nebula—such as the Cat's Eye Nebula pictured—are relatively short-lived. They last a few tens of thousand years, rather than several billion years.

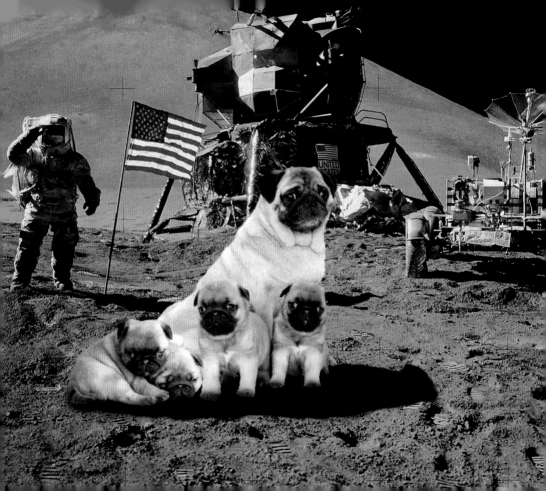

Dogsitter Wanted

"We tell the pups bedtime stories about brown dwarfs. That keeps them from wandering off into infinity."

Pug Fact: Pug puppies are called "puglets."

Space Fact: The farthest thing you can see without a telescope is a collection of stars known as the Andromeda Galaxy. It is about 2.7 million light years away.

THE
END